SCANDINAVIAN FOLK DESIGNS

by

Lis Bartholm

DOVER PUBLICATIONS, INC., NEW YORK

Publisher's Note

The motifs of the folk arts of Scandinavia have long been admired for their exuberance and decorative aptness. Lis Bartholm, a Dane who has devoted her energies to such traditional crafts as rosemaling and painting china, has created her own adaptations of the most appealing of these designs. But their application need not be limited to the traditional; they can be used in a wide variety of graphics and crafts projects that require a "folk" touch.

Copyright © 1988 by Dover Publications, Inc.

All rights reserved under Pan American and International Copyright Conventions.

Published in Canada by General Publishing Company, Ltd., 30 Lesmill Road, Don Mills, Toronto, Ontario.

Published in the United Kingdom by Constable and Company, Ltd., 10 Orange Street, London WC2H 7EG.

Scandinavian Folk Designs is a new work, first published by Dover Publications, Inc., in 1988.

DOVER *Pictorial Archive* SERIES

Manufactured in the United States of America
Dover Publications, Inc., 31 East 2nd Street, Mineola, N.Y. 11501

Library of Congress Cataloging-in-Publication Data

Bartholm, Lis.
 Scandinavian folk designs / by Lis Bartholm.
 p. cm.
 ISBN 0-486-25578-6 (pbk.)
 1. Decoration and ornament—Scandinavia. 2. Folk art—Scandinavia. I. Title.
NK1457.A1B37 1988
745.4'4948—dc19 87-27795
 CIP

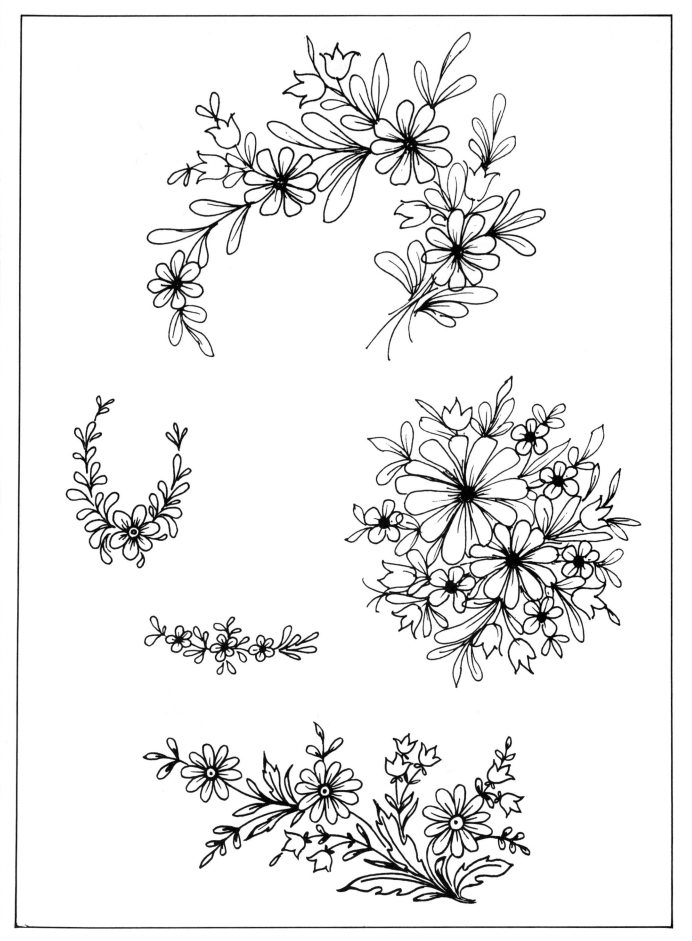

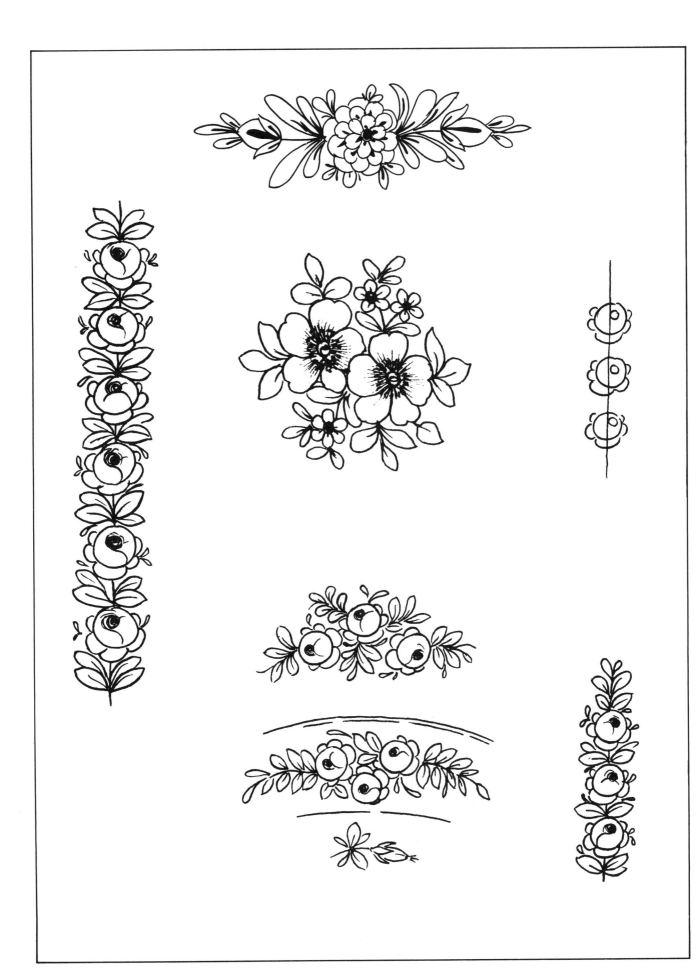

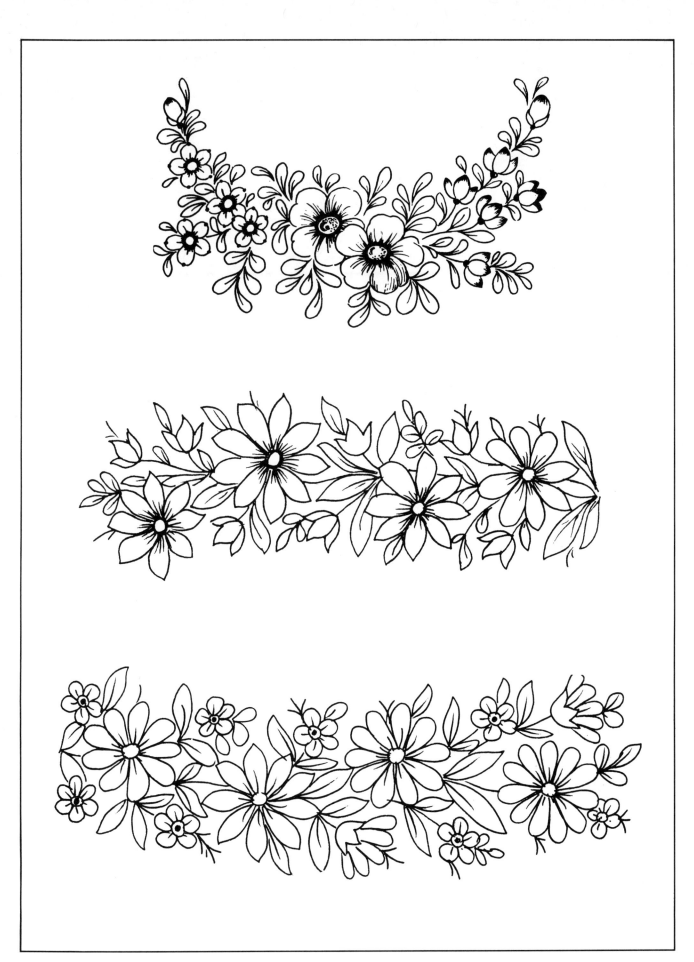

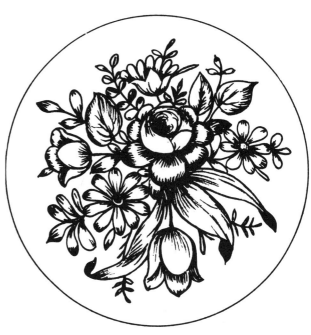

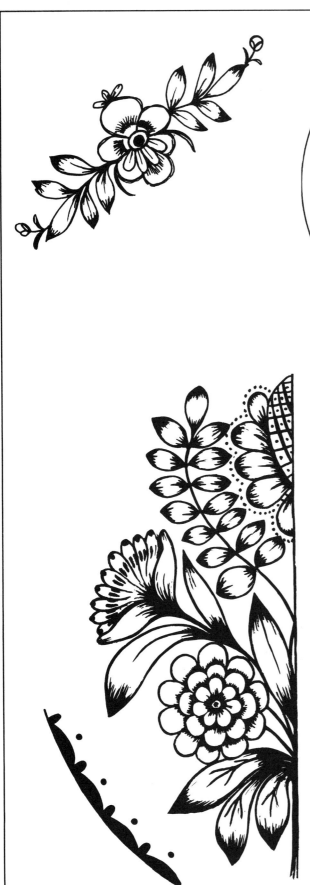

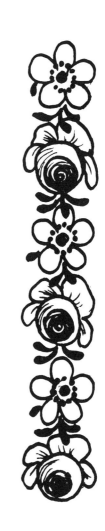

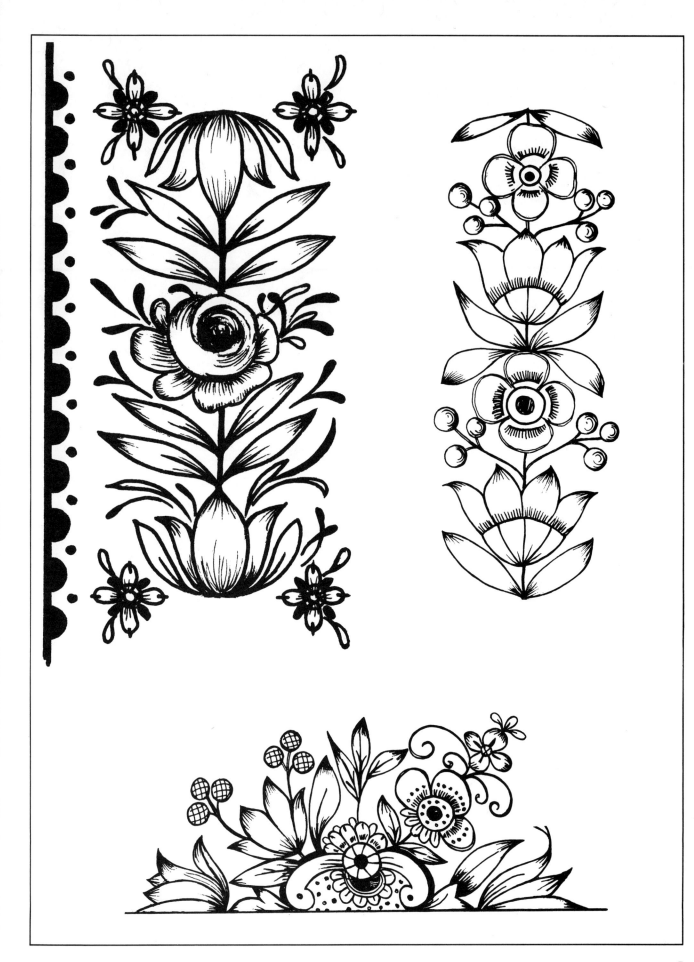

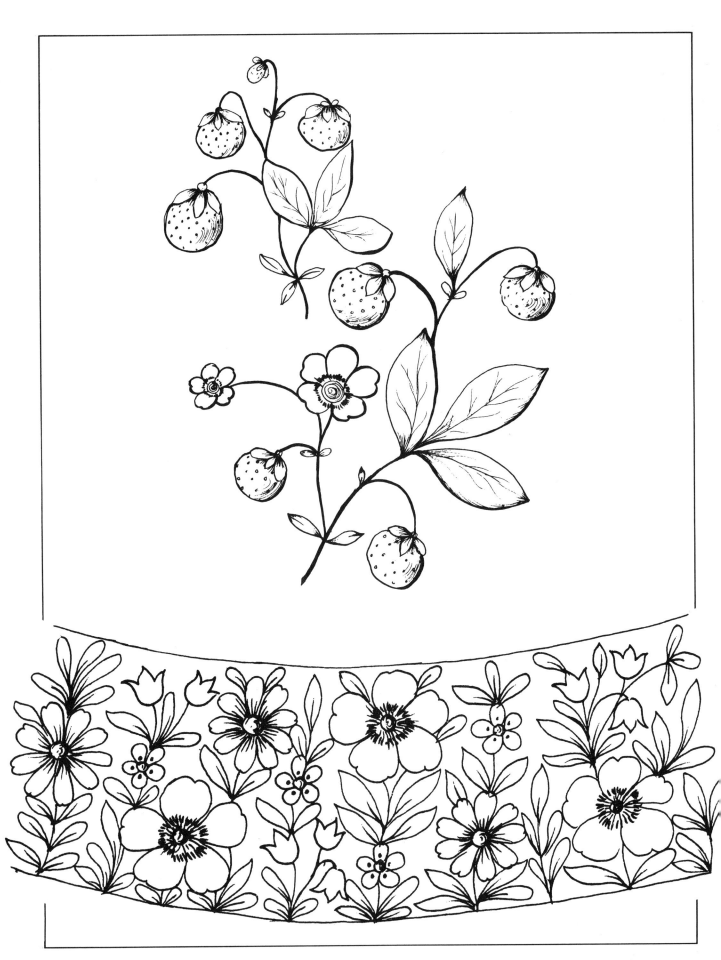

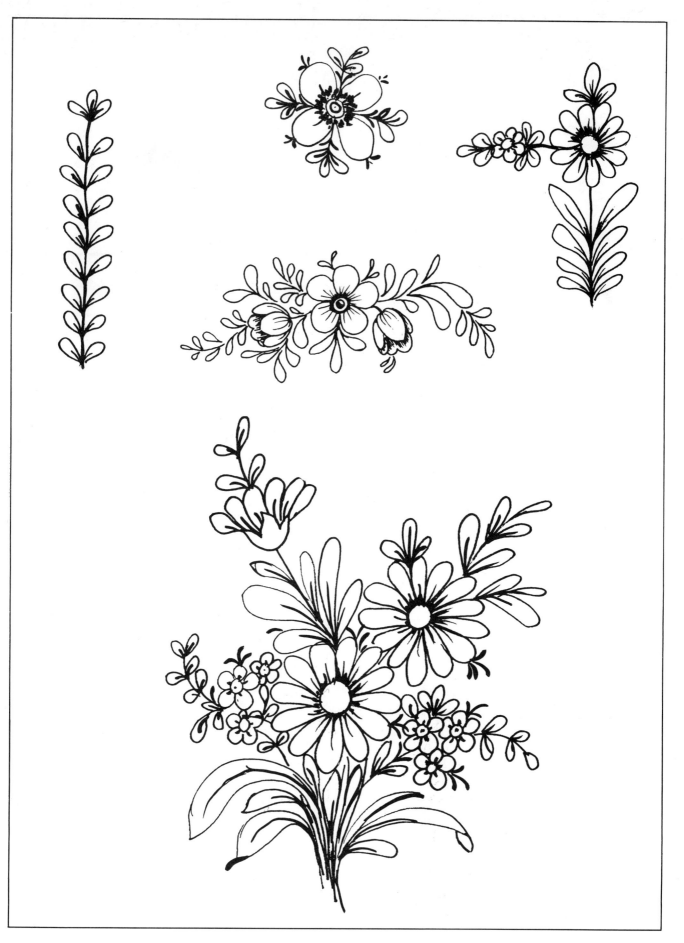

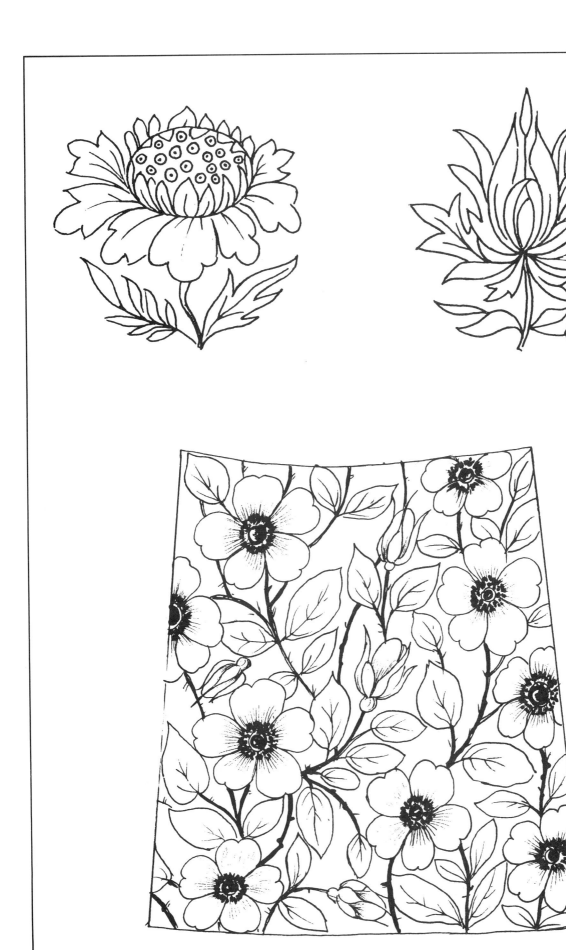

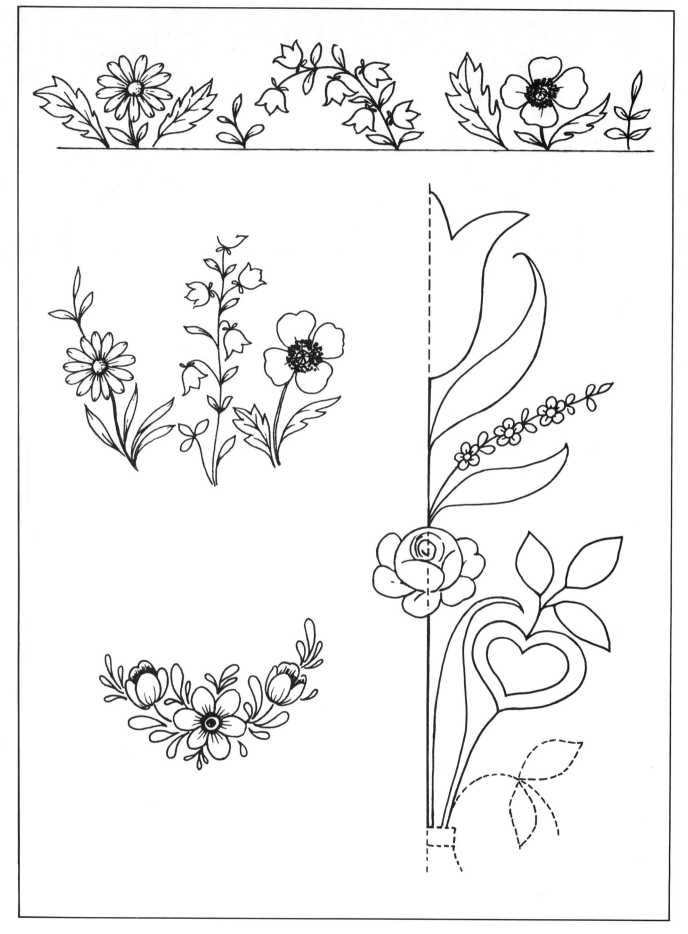

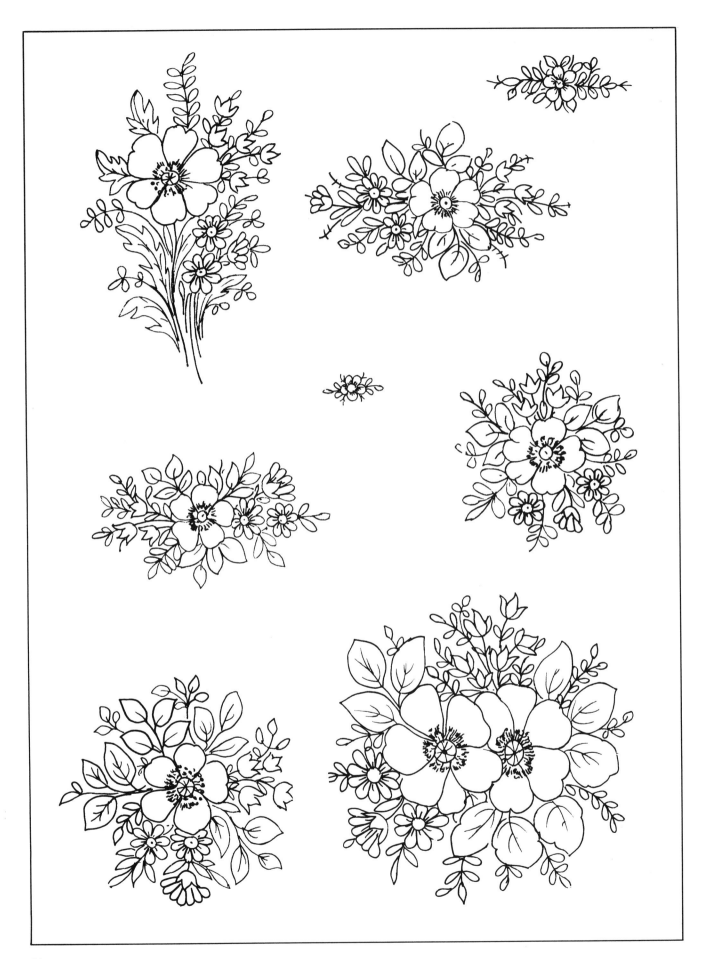

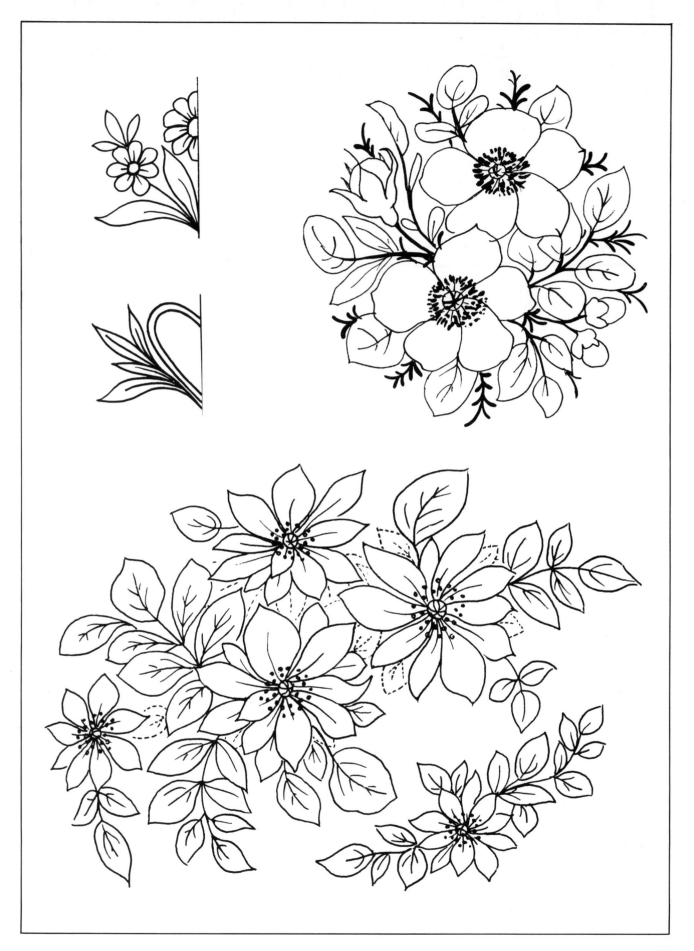

11

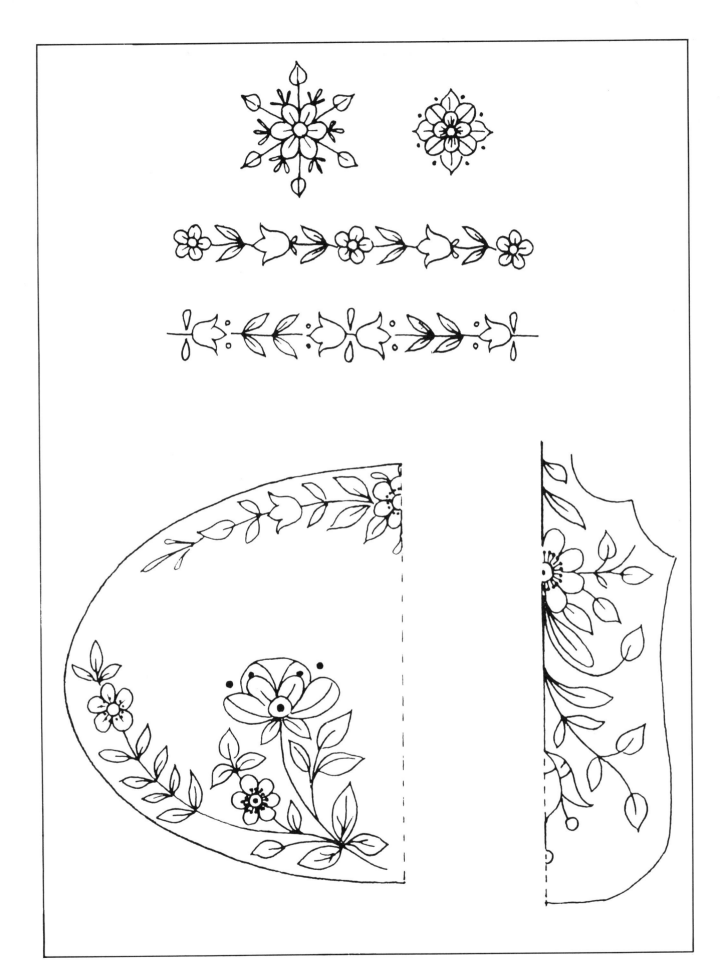

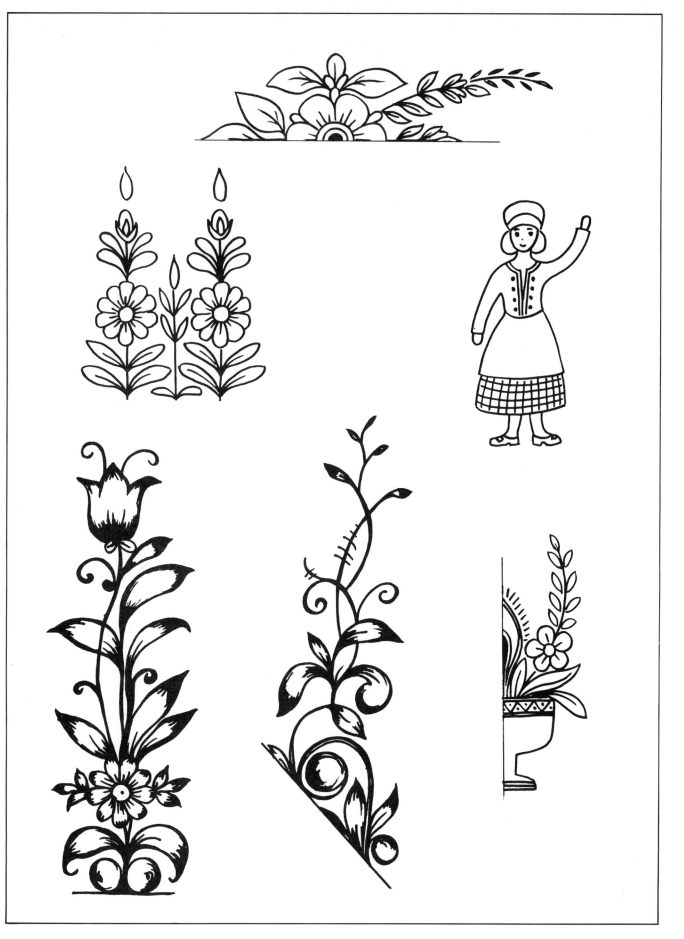

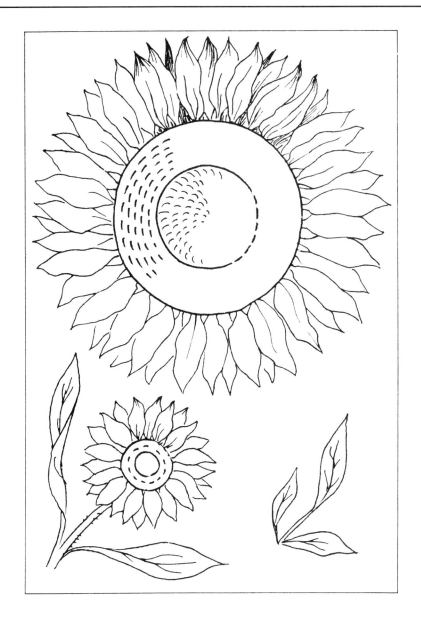

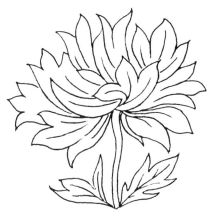

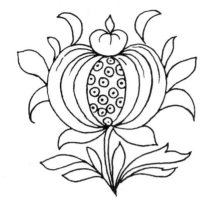

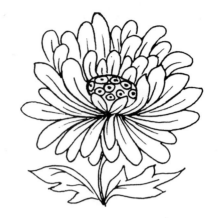

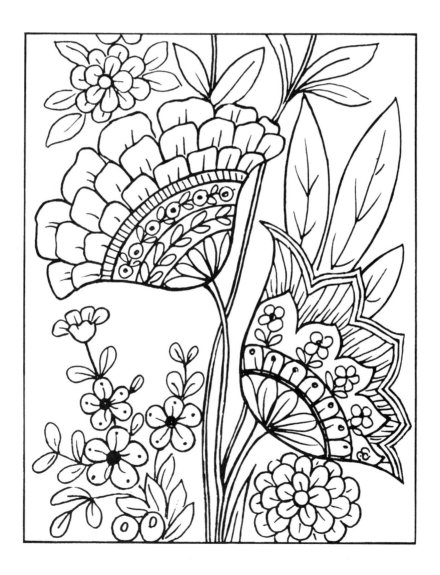

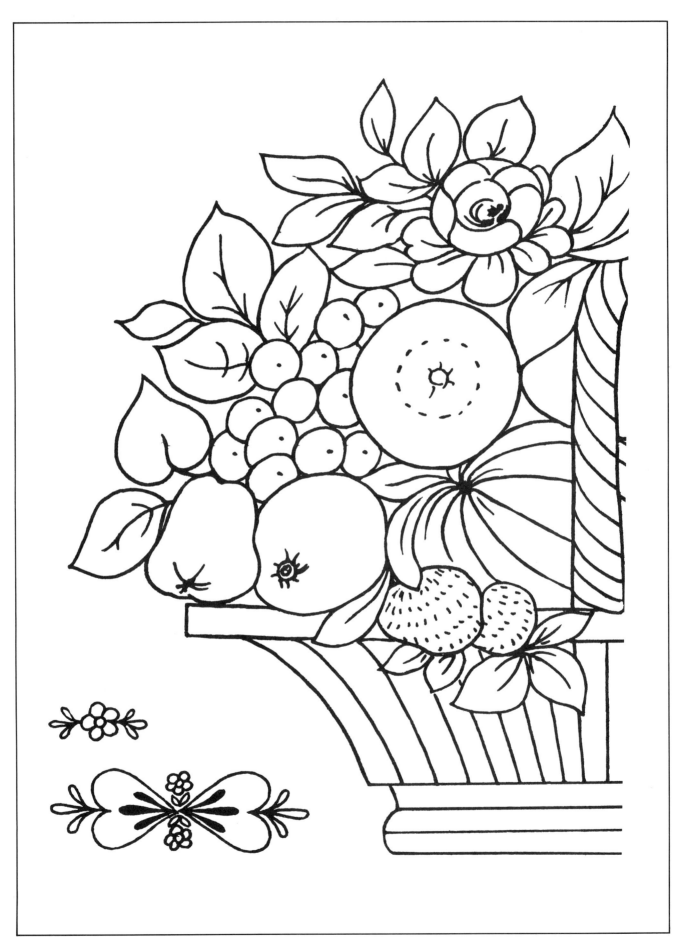

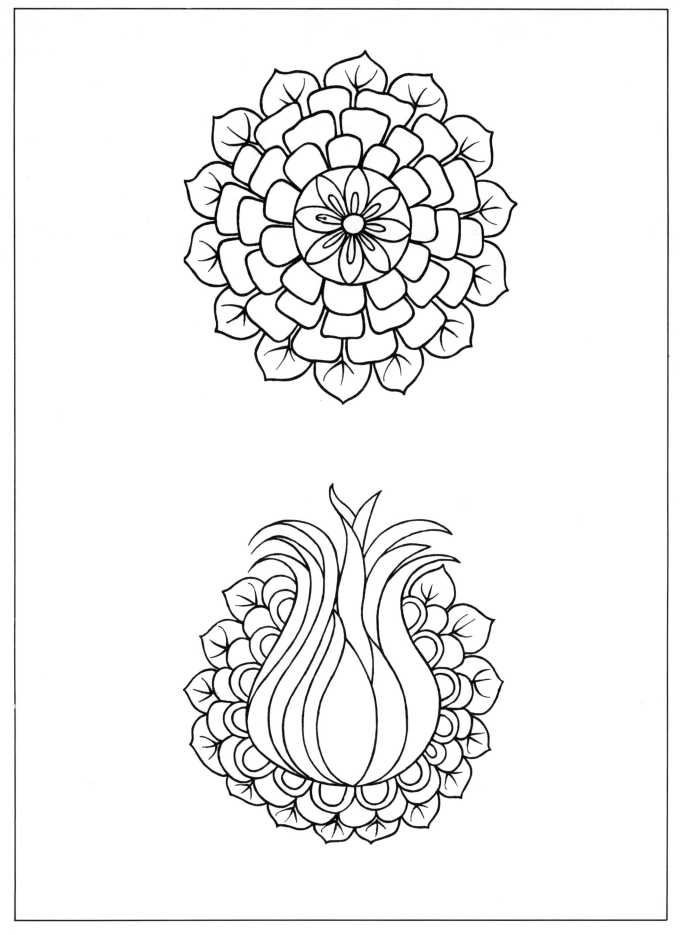

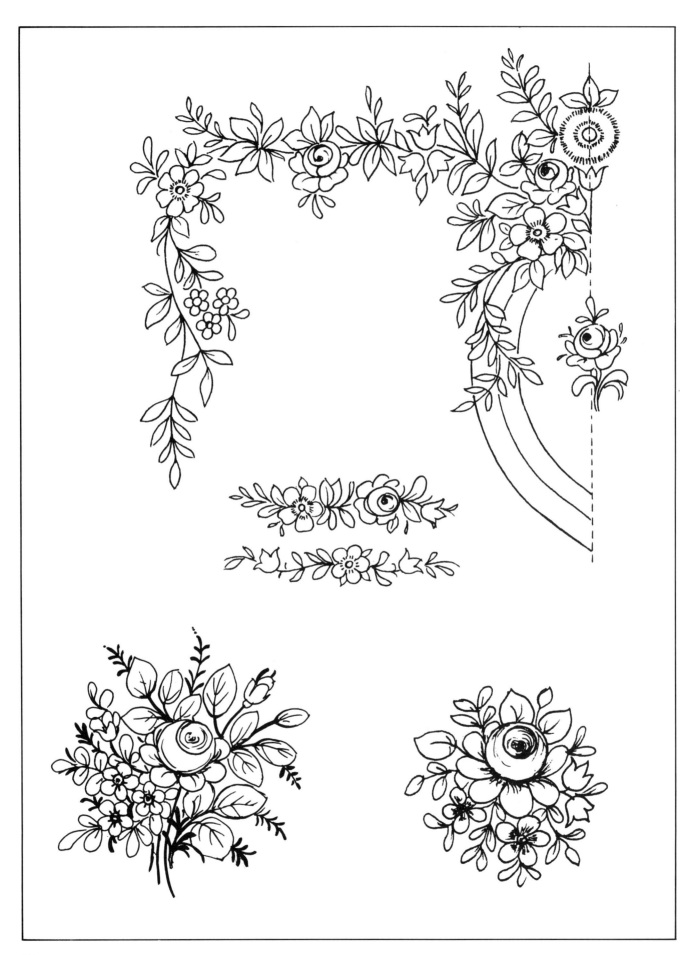

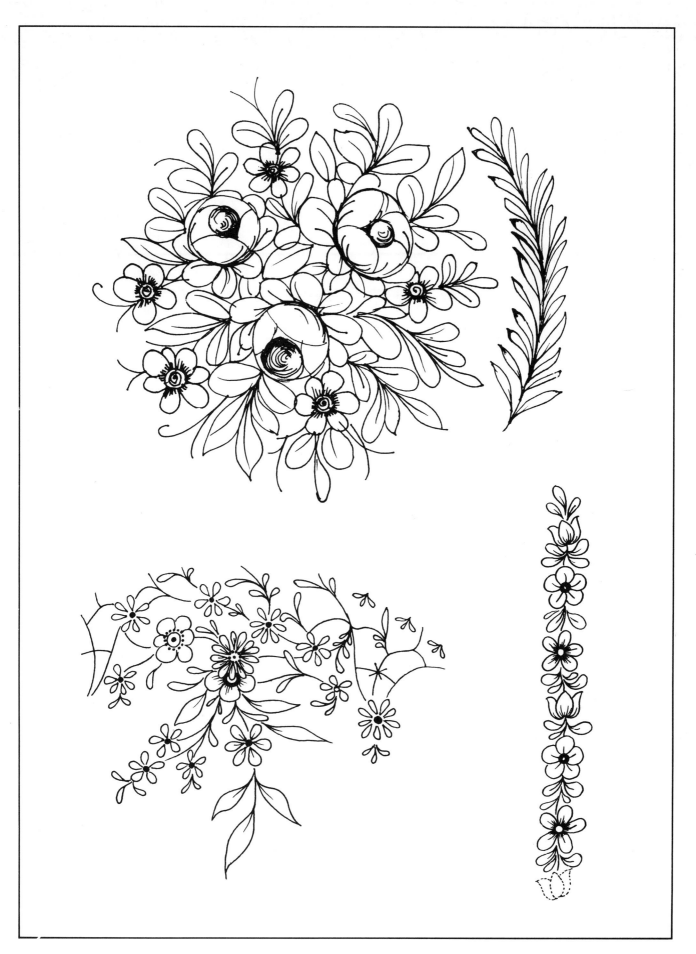

19

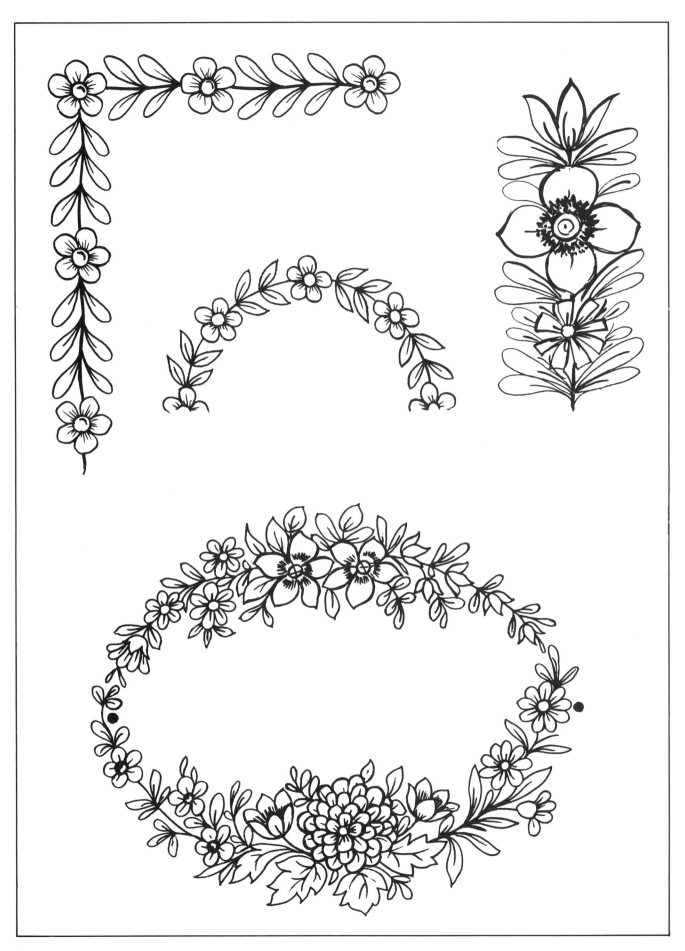

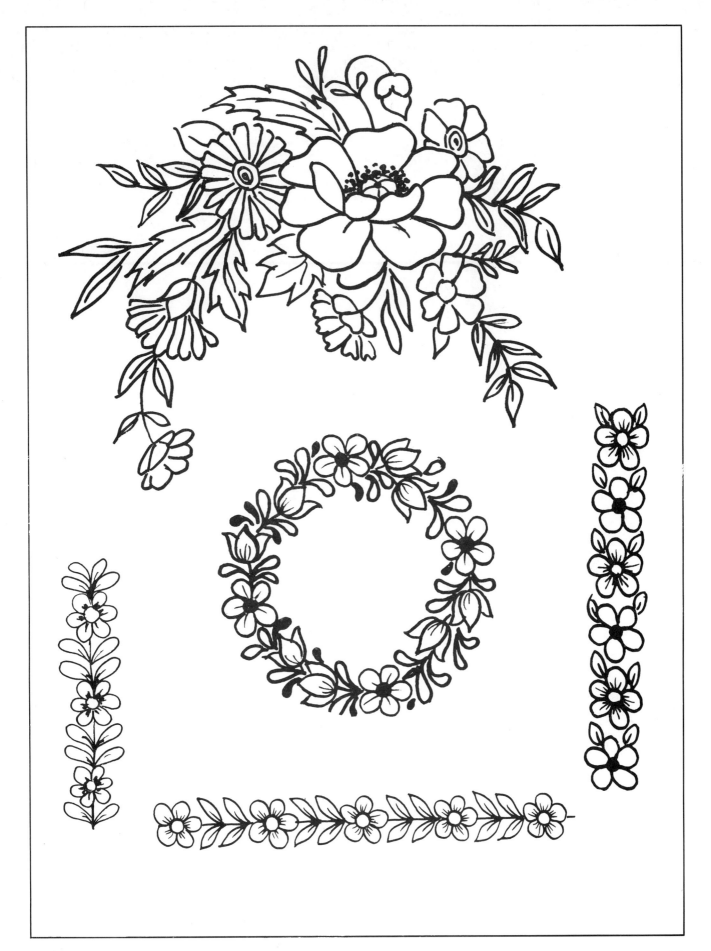

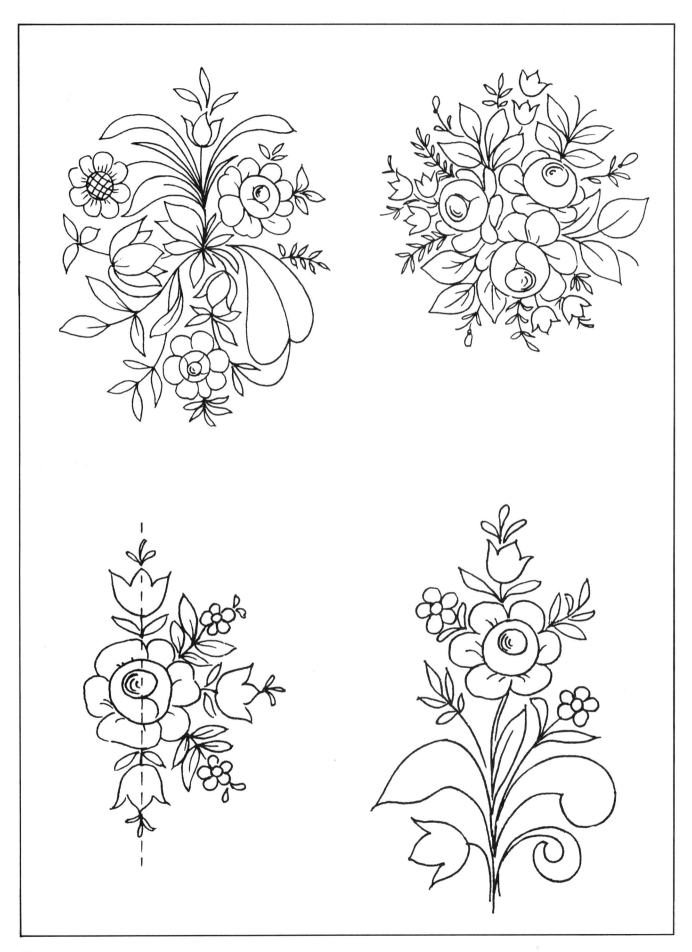

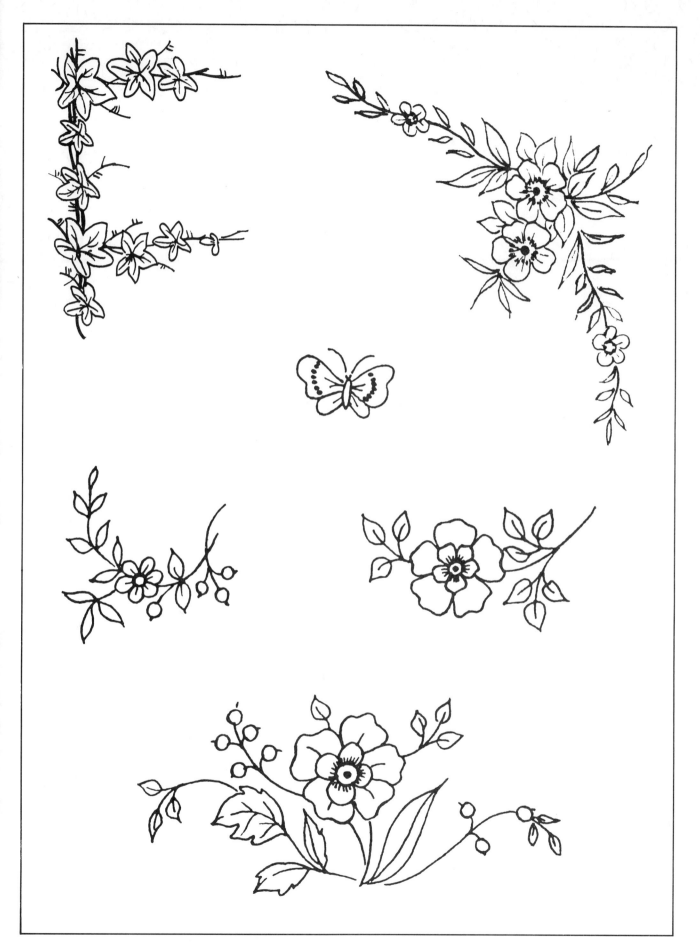

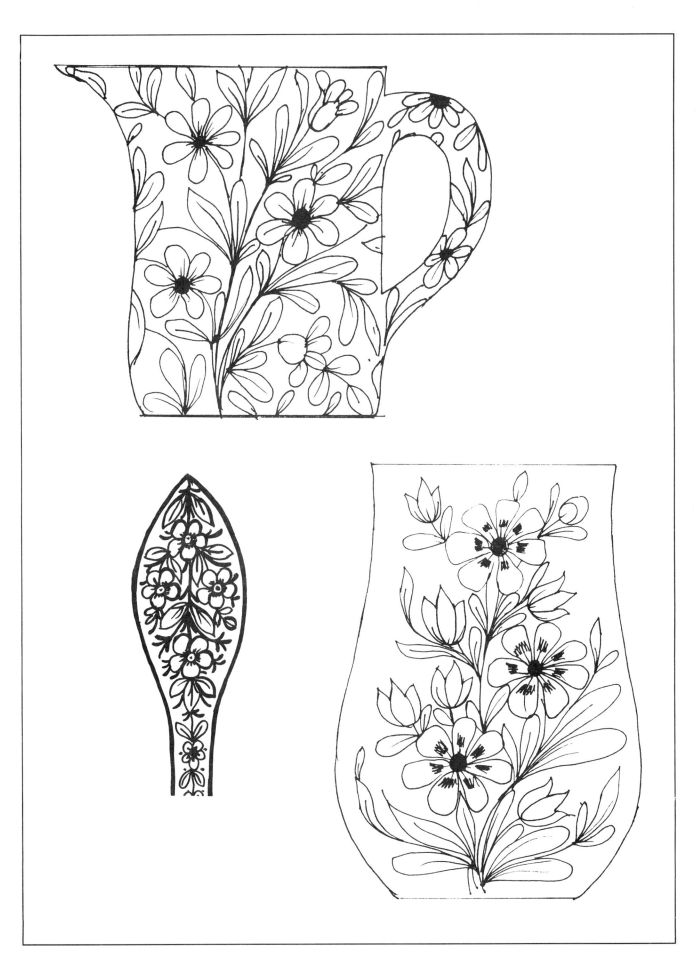

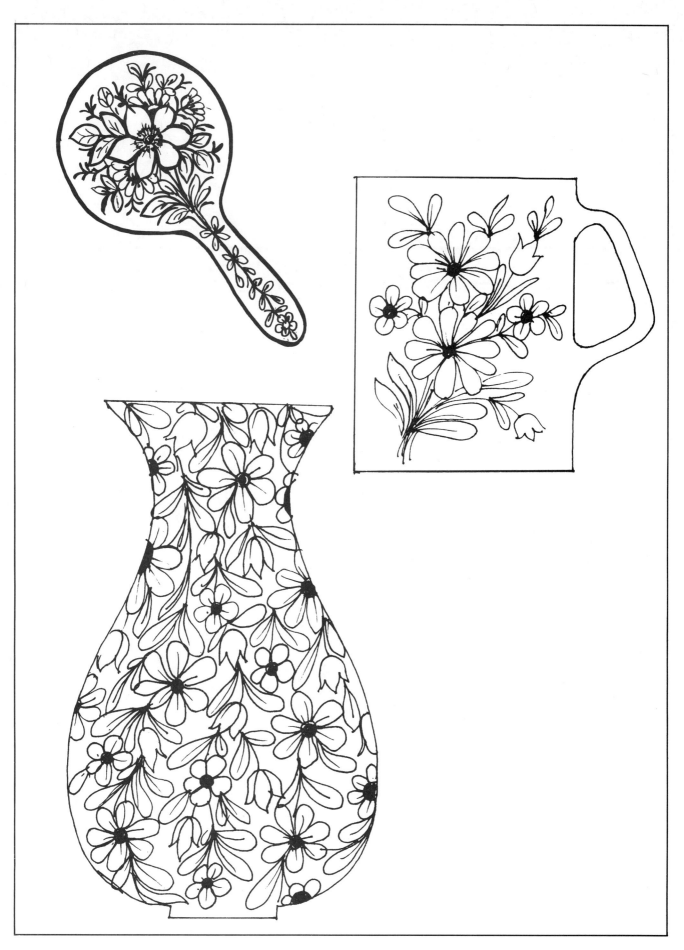

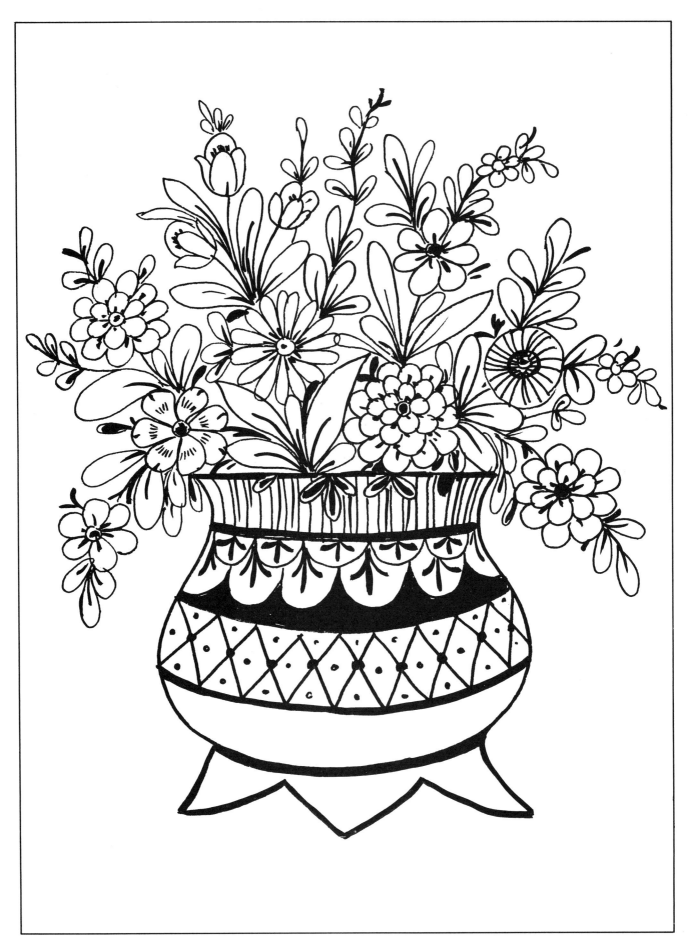

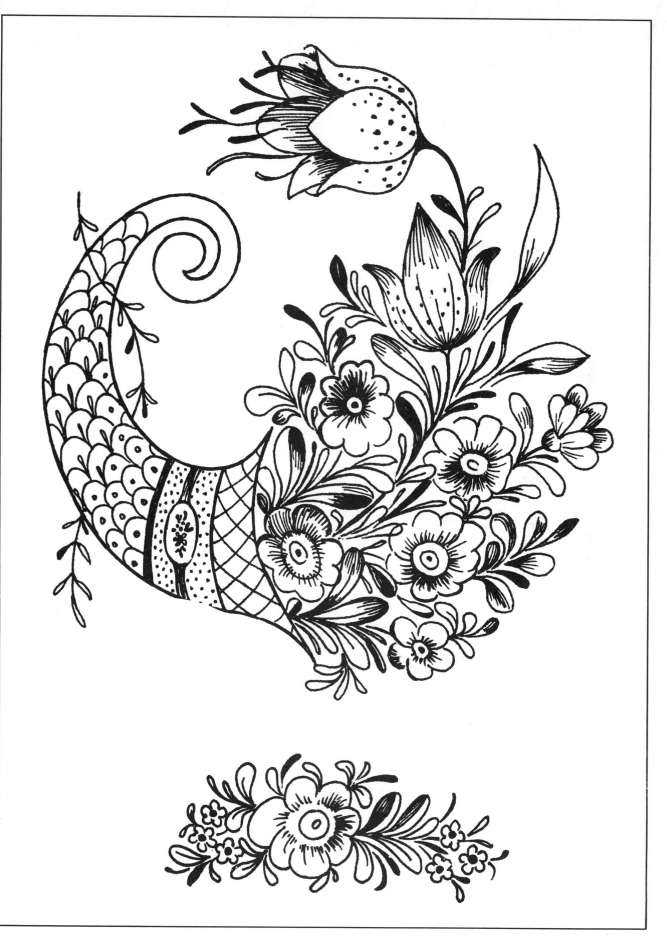

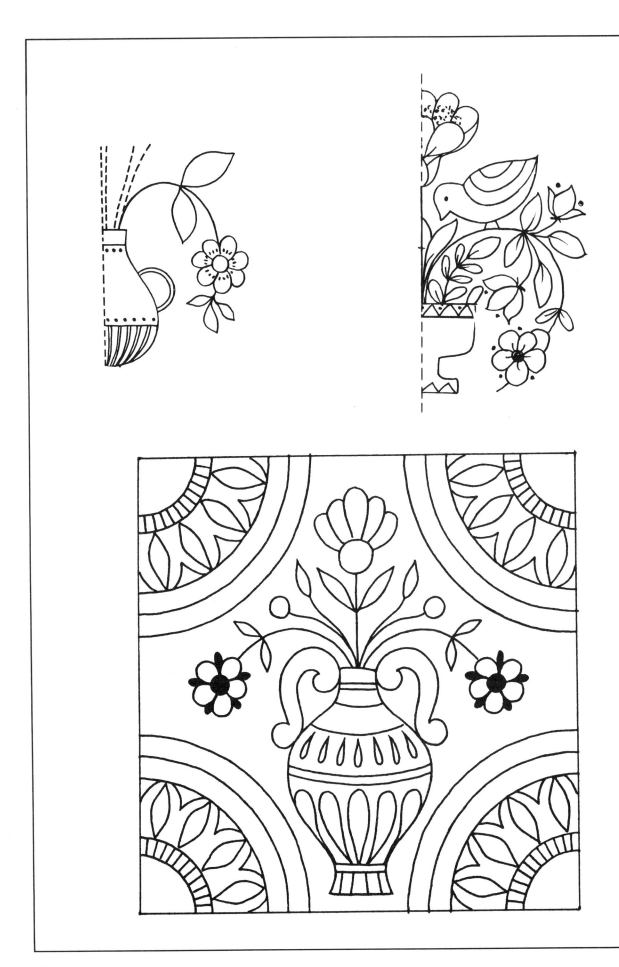

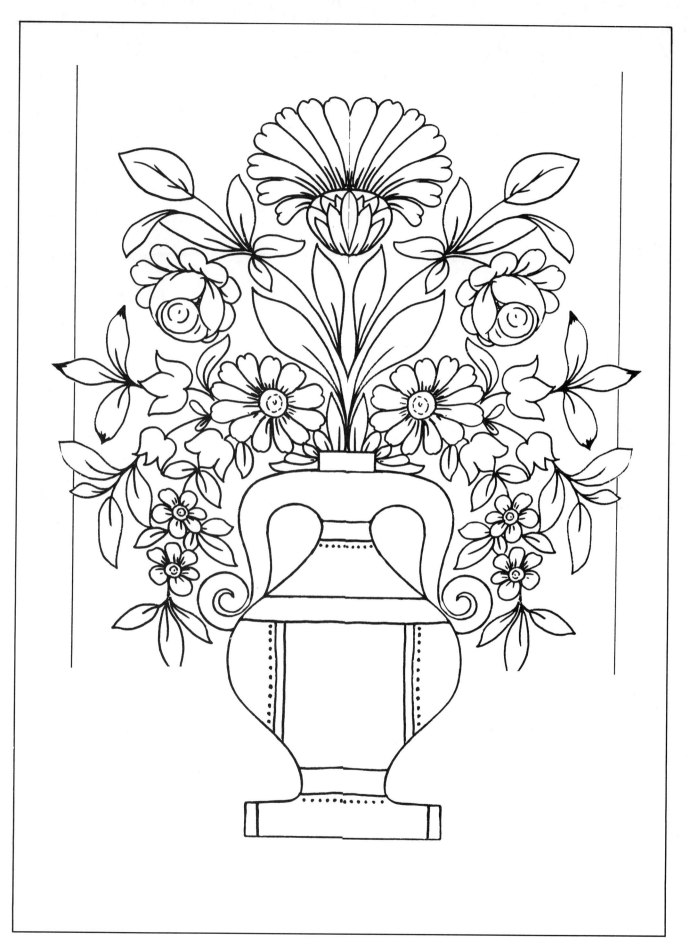

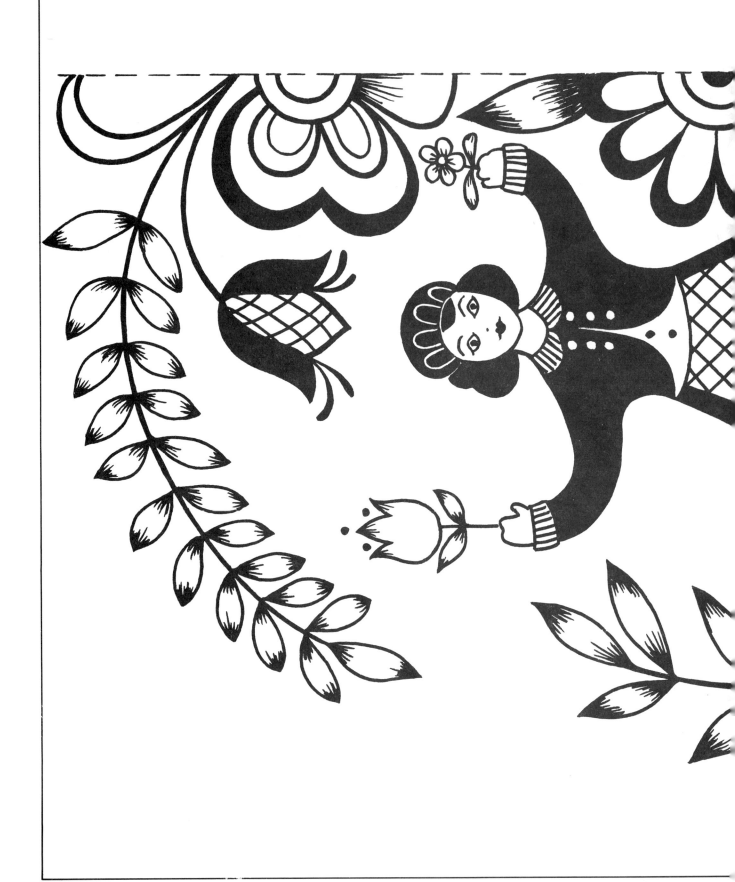

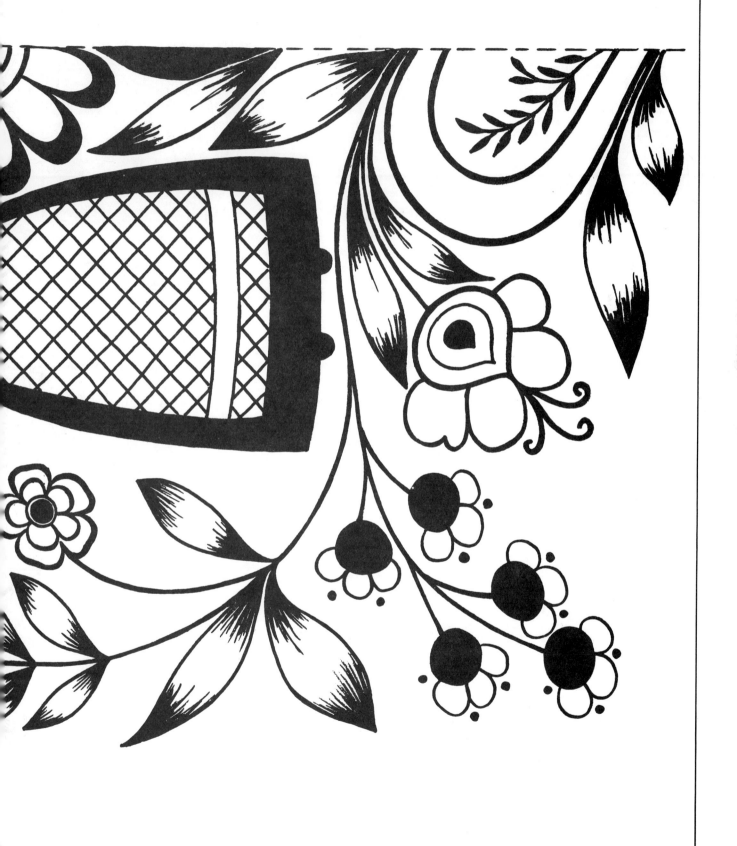

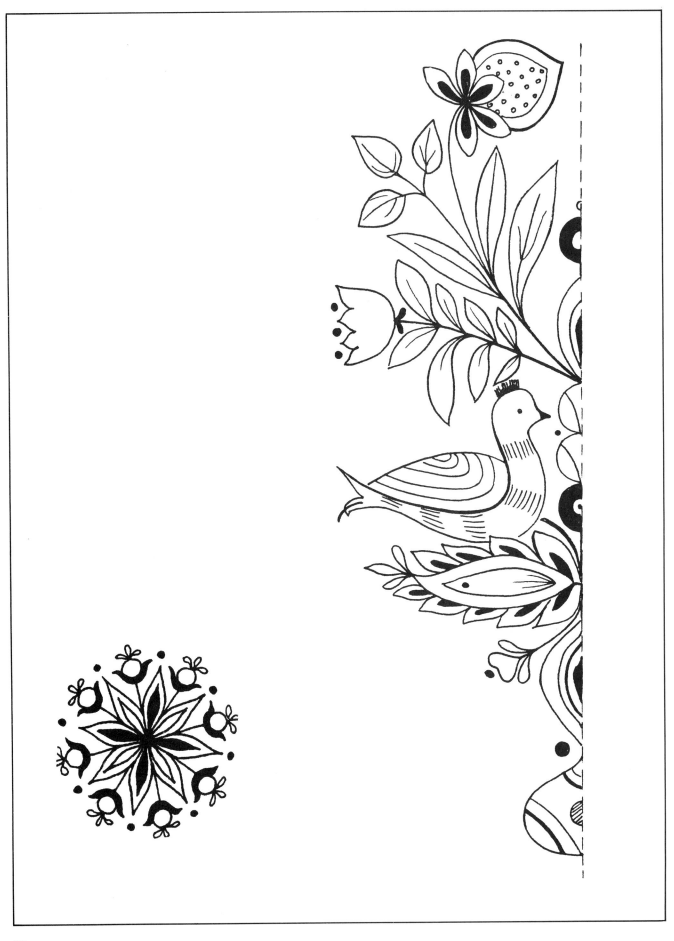

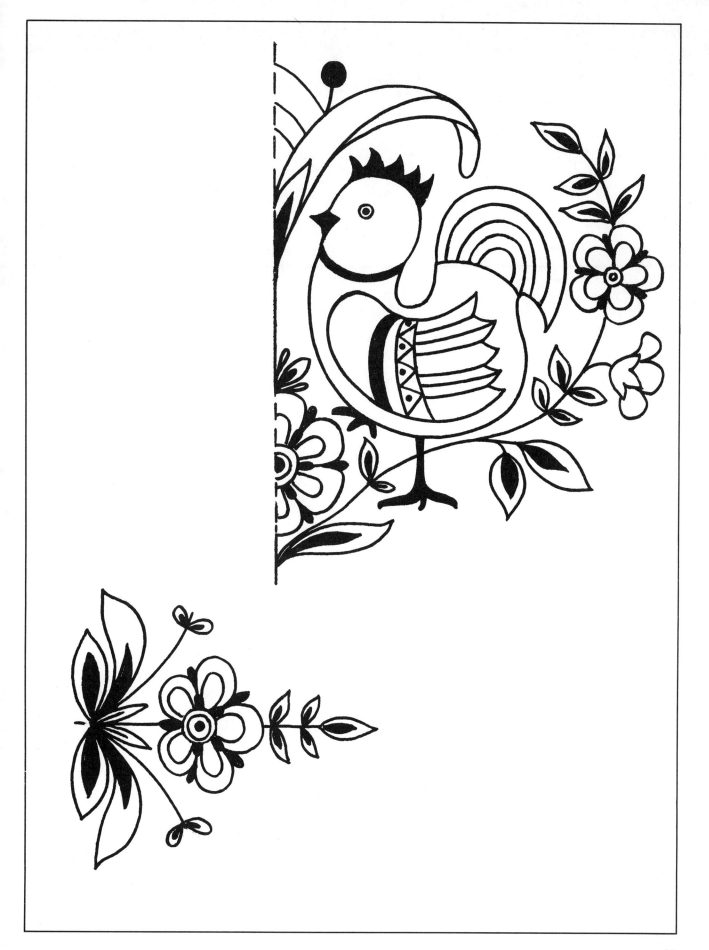

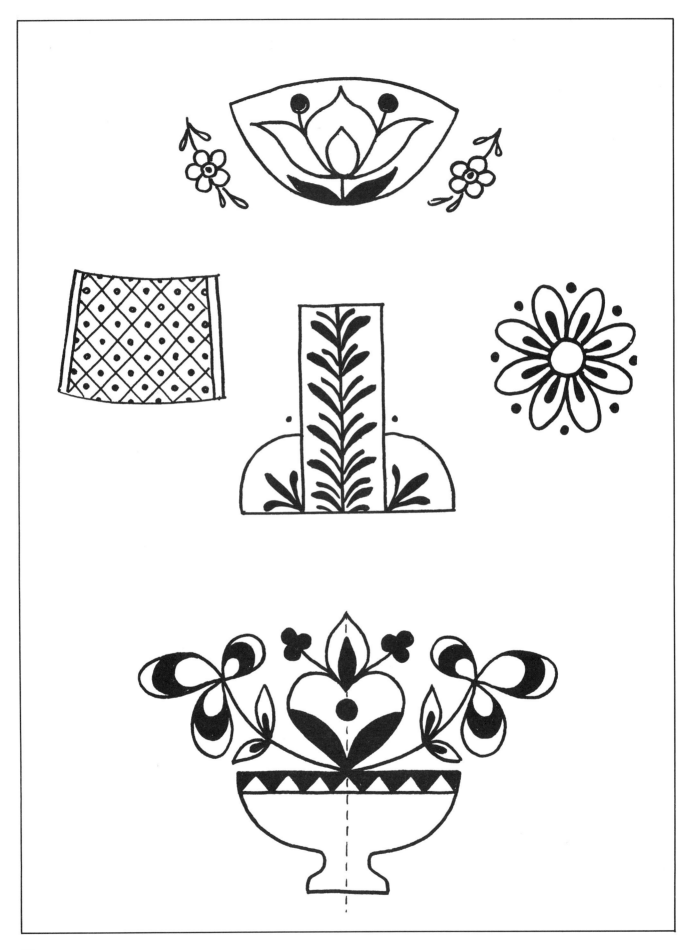

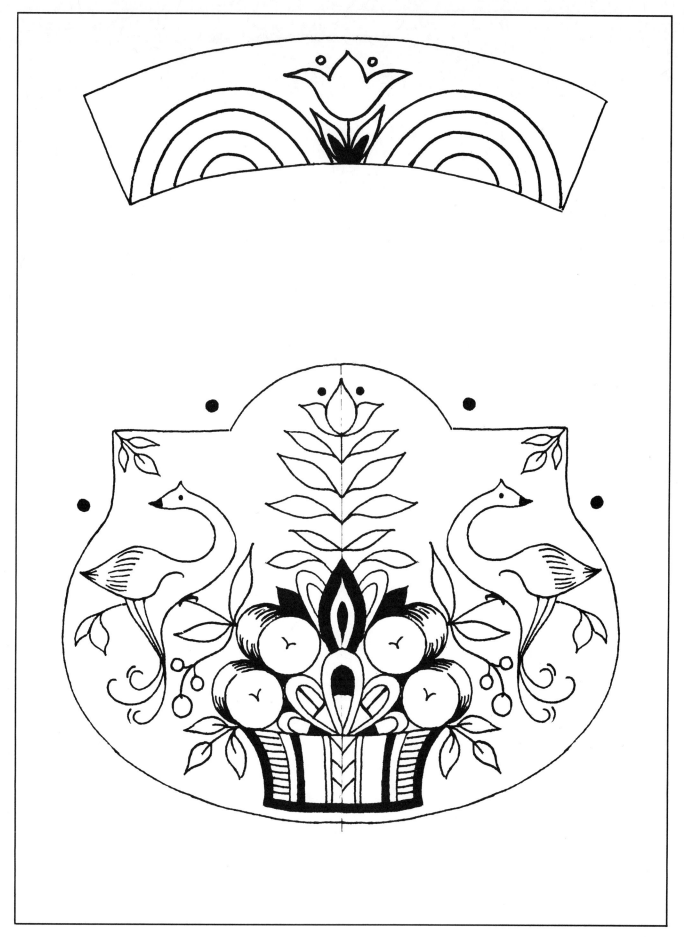

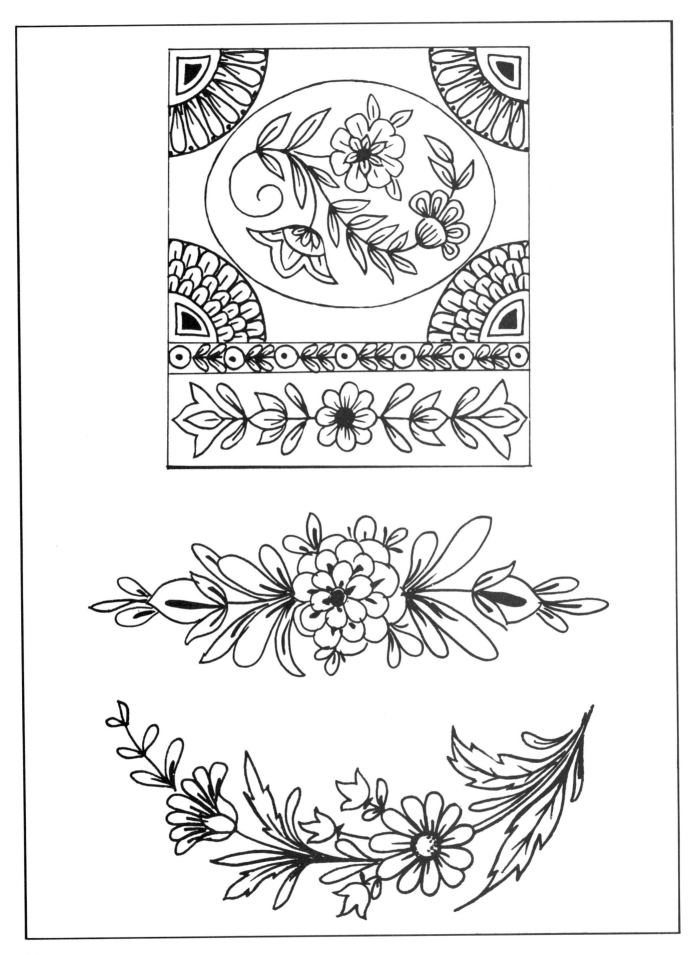

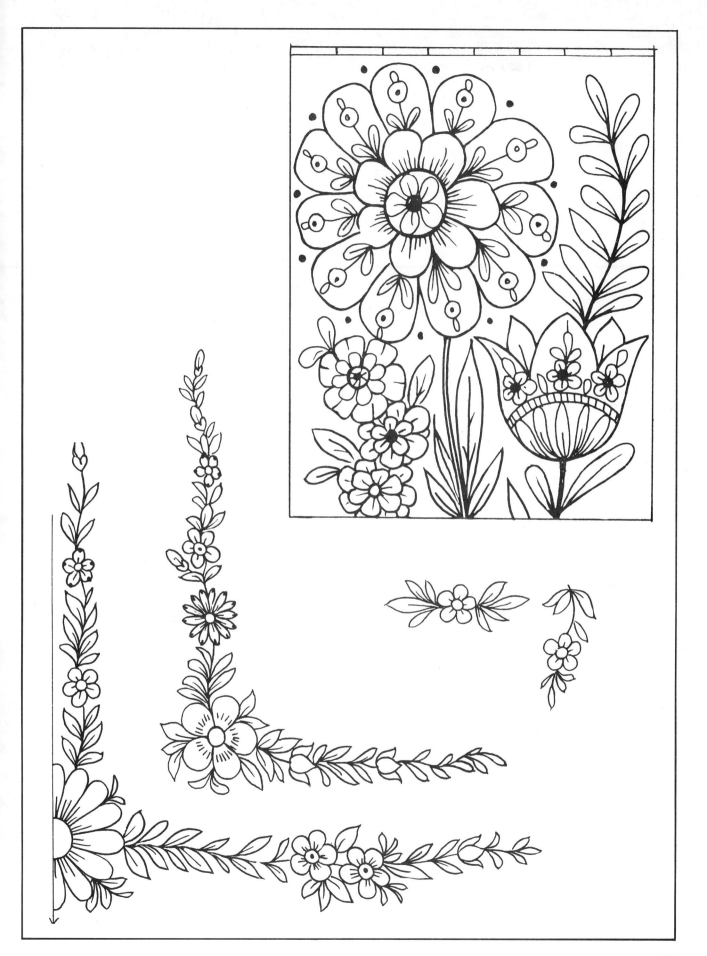

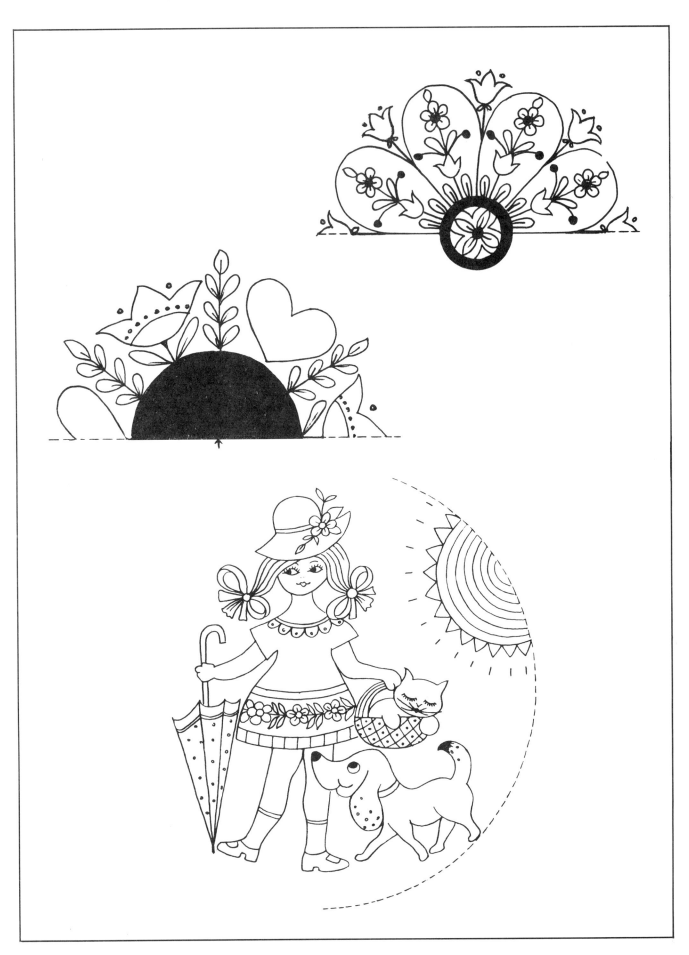

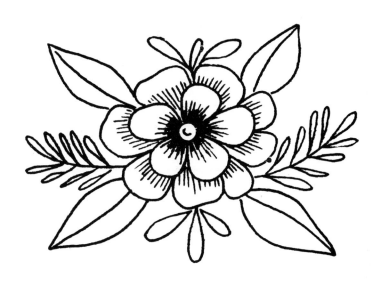

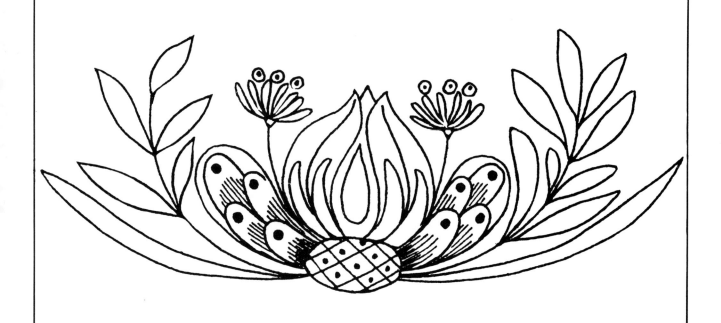

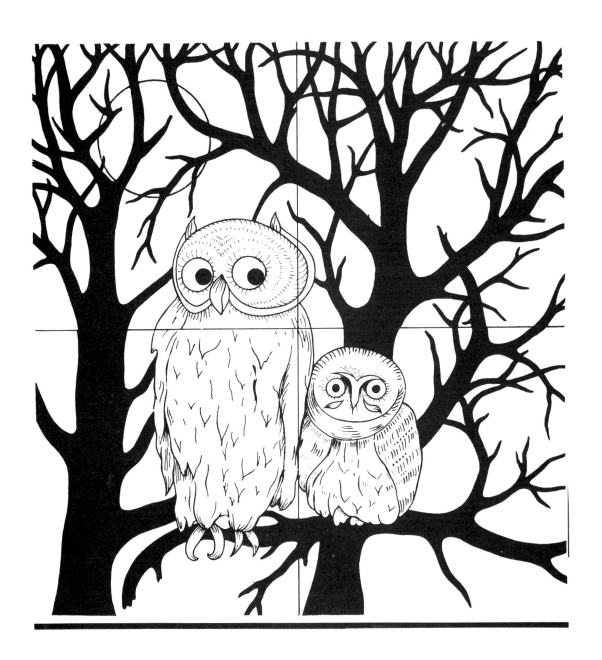

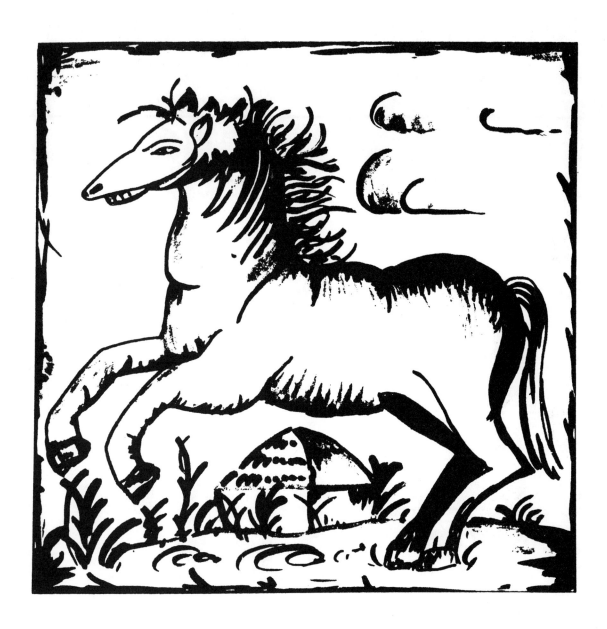

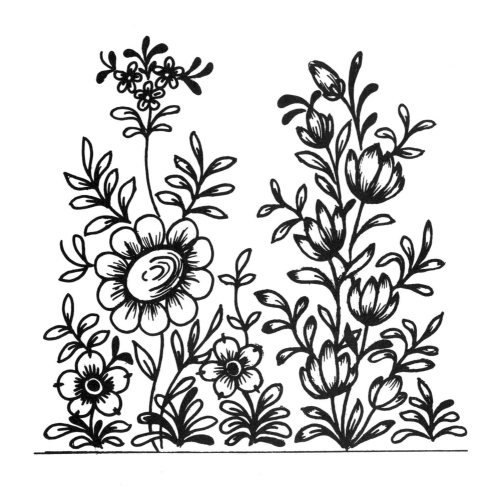

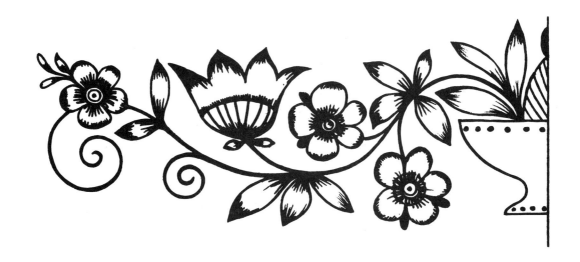

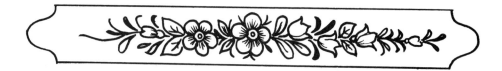

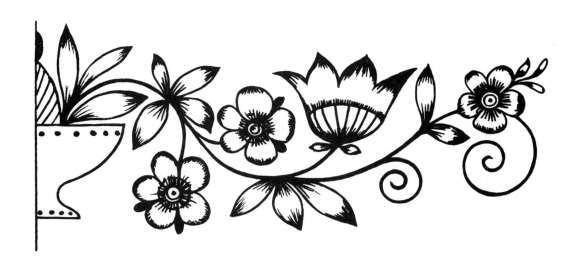

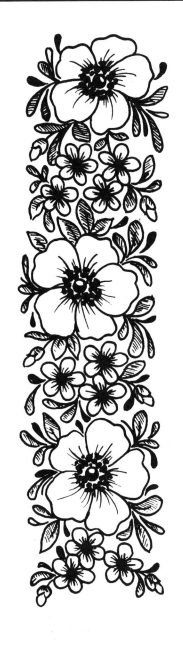
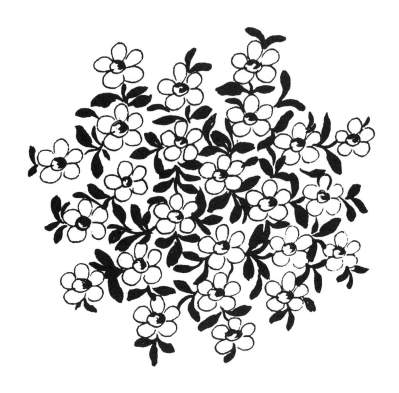
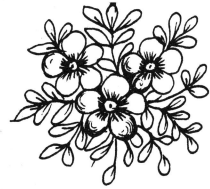
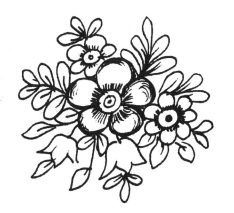

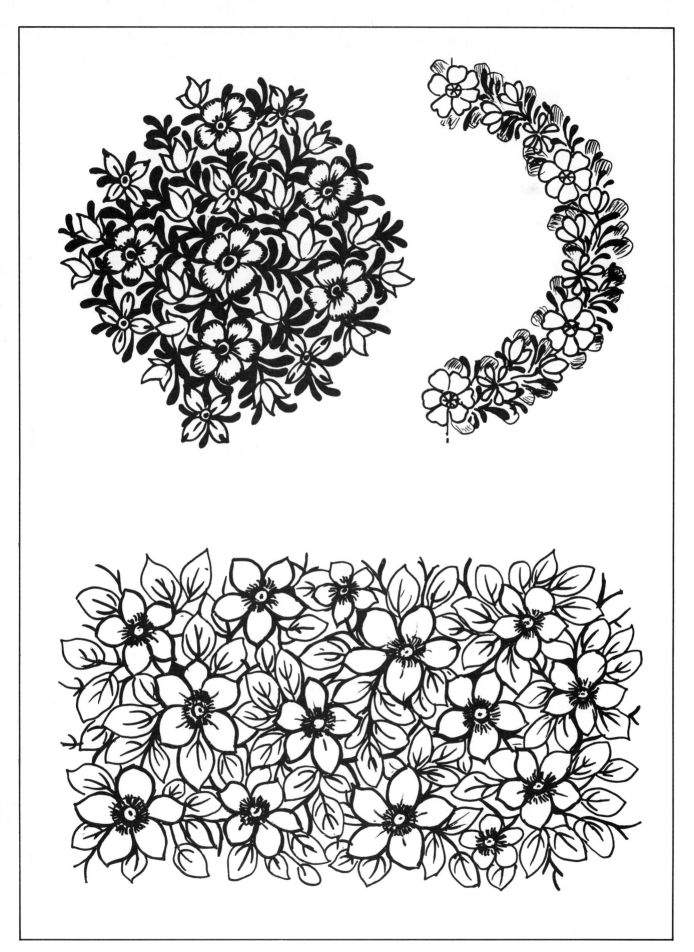